"*Last Meal* is a menu of disgust: a sure way of p[...]
fare of judicial murder. But it contains some ess[...]
nourishment, and also anticipates the more who[...] [...]ght that is
within our reach."

—Christopher Hitchens

"This powerful and disturbing book gives invaluable insight into the inhumanity of the death penalty, while providing a snapshot of the humanity and individuality of those on death row. Jacquelyn C. Black's work is a stark and potent reminder of the brutality of capital punishment how, by imposing death upon fellow human beings, we negate the sanctity of life."

—Liz Garbus,
Oscar-Nominated Director of 'The Farm', and
'The Execution Wanda Jean'

"*Last Meal* is a book more about life than death, more about the innate good-ness of man, rather than the evil. I wept as I scanned its pages, and thanked the powers that be that I, too, did not join them in a desperate time. It's a thin line, ever, that divides us."

—Gerry Spence
Founder of the Trial Lawyers College
and best-selling author

Cover & Book Design by Lubna Abu-Osba

Published by
Common Courage Press
Box 702
Monroe, ME 04951
(207) 525-0900; fax: (207)525-3068
orders-info@commoncouragepress.com

First printing.

Library of Congress Cataloging in Publication Data is available from
the publisher on request.
ISBN 1-56751-240-2 paper
ISBN 1-56751-241-0 cloth
Printed in Canada

...last meal.

JACQUELYN C. BLACK
COMMON COURAGE PRESS
MONROE, MAINE

Author's note:

This book recreates the last meals of 23 individuals who were tried, convicted, and executed in Texas for capital murder. In some cases last statements have been edited for length and clarity. Ellipses denote edit points.

To SAB
"the better workman"
&
MLJS

Since 1976 when the death penalty was reinstated, over 821 men and women have been executed in the United States.

THE TRADITION OF FEEDING

A LAST MEAL TO THE CONDEMNED

DATES BACK TO ANCIENT GREECE.

NAME: CHARLES FRANCES RUMBAUGH

EXECUTED: SEPTEMBER 11, 1985

(NO BACKGROUND INFO. GIVEN)

LAST STATEMENT: "...ABOUT ALL I CAN SAY IS
GOODBYE, AND FOR ALL THE REST OF YOU, ALTHOUGH
YOU DON'T FORGIVE ME FOR MY TRANSGRESSIONS, I
FORGIVE YOURS AGAINST ME. I AM READY TO BEGIN
MY JOURNEY..."

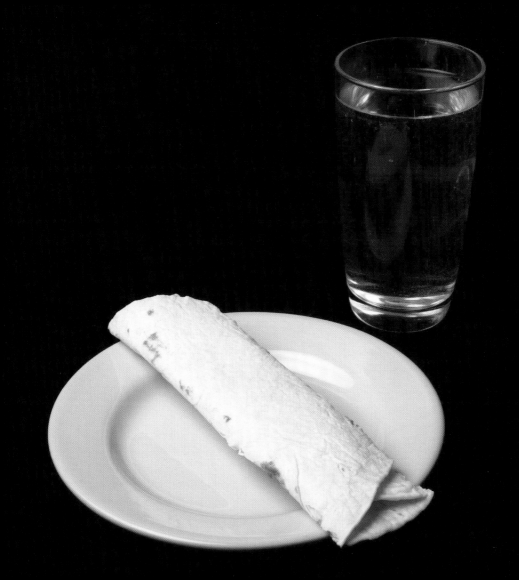

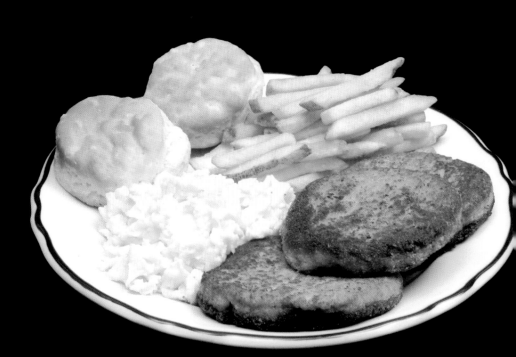

NAME: CLYDELL COLEMAN

EXECUTED: MAY 5,1999

EDUCATION: 11 YEARS

OCCUPATION: JANITOR

LAST STATEMENT: NO LAST STATEMENT

COUNTRIES WITH THE MOST
EXECUTIONS IN 1998:

CHINA 1067

DEMOCRATIC REPUBLIC
OF CONGO 100

UNITED STATES 68

IRAN 66

EGYPT 48

BELARUS 33

TAIWAN 32

SAUDI ARABIA 29

Amnesty International, documented cases. Actual figures likely to be higher

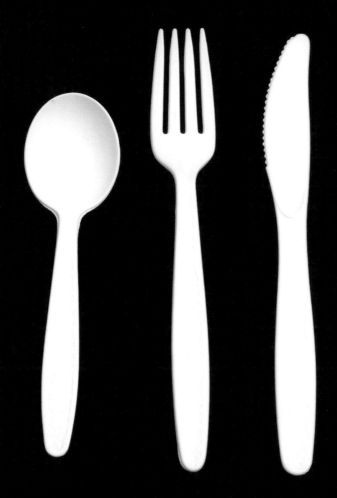

Like the general prison population, the condemned use plastic cutlery.

There are 12 states in addition to the District of Columbia today that do not employ capital punishment. They are Alaska, Hawaii, Iowa, Maine, Massachusetts, Michigan, Minnesota, North Dakota, Rhode Island, West Virginia, Wisconsin, and Vermont.

These states do not have higher homicide rates than states with the death penalty.

In fact, 10 of the 12 have homicide rates below the national average.

The New York Times, 9/00

TEXAS HAS EXECUTED 295 MEN AND WOMEN SINCE 1976, FAR MORE THAN ANY OTHER STATE AND ABOUT A THIRD OF THE COUNTRY'S TOTAL.

NAME: CHARLES WILLIAM BASS

EXECUTED: MARCH 12, 1986

(NO BACKGROUND INFO. GIVEN)

LAST STATEMENT: "I DESERVE THIS.
TELL EVERYONE I SAID GOODBYE."

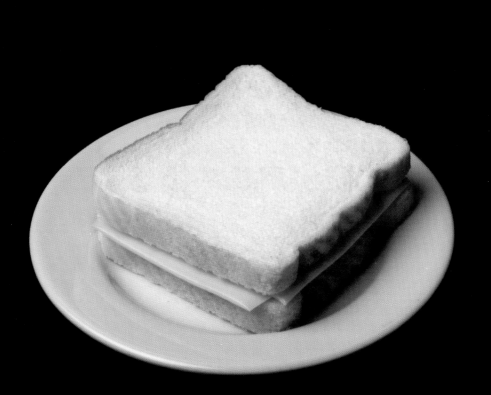

NO DOLLAR LIMIT IS PLACED ON
AN INMATE'S LAST MEAL REQUEST.
BUT FOOD ITEMS MUST BE READILY
AVAILABLE IN THE PRISON KITCHEN.

The prisoner is served the last meal
2 hours before execution.

Under Texas prison regulations, alcohol
and tobacco are denied.

But they are often requested.

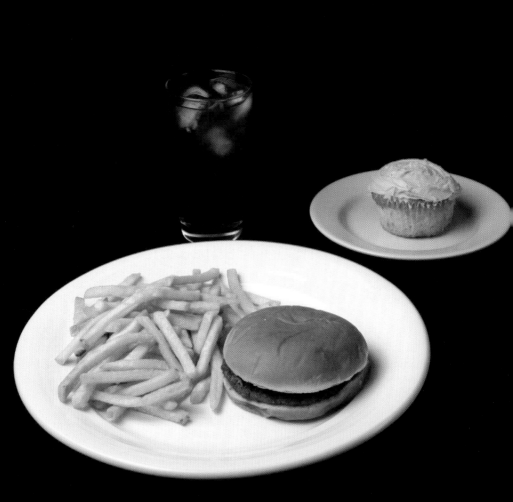

NAME: BILLY CONN GARDNER

EXECUTED: FEBRUARY 16, 1995

EDUCATION: 12 YEARS

OCCUPATION: WELDER

LAST STATEMENT: "I FORGIVE ALL OF YOU—
HOPE GOD FORGIVES ALL OF YOU TOO."

Studies in Florida, North Carolina, and Texas show the estimated average cost of an execution to be $2.5 million.

The Georgia Department of Corrections states that $18,000 is the cost per year to house an inmate in maximum security.

THE MONETARY COST
OF A DEATH PENALTY CASE
IS FAR HIGHER THAN A
LIFETIME OF INCARCERATION.

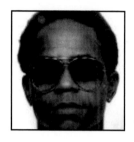

NAME: JAMES RUSSELL

EXECUTED: SEPTEMBER 19, 1991

EDUCATION: 10 YEARS

OCCUPATION: MUSICIAN

LAST STATEMENT: (LAST STATEMENT REPORTED TO HAVE LASTED 3 MINUTES, BUT IT WAS EITHER NOT TRANSCRIBED OR NOT RECORDED)

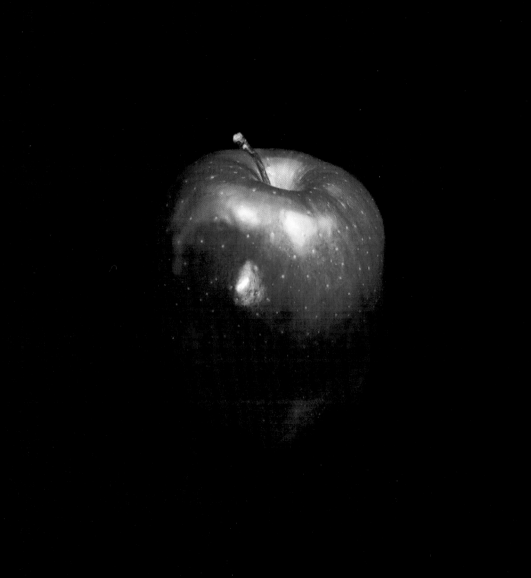

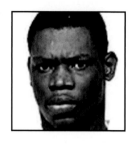

NAME: ANTHONY RAY WESTLEY

EXECUTED: MAY 13, 1997

EDUCATION: 8 YEARS

OCCUPATION: LABORER

LAST STATEMENT: "I WANT YOU TO KNOW THAT
I DID NOT KILL ANYONE. I LOVE YOU ALL."

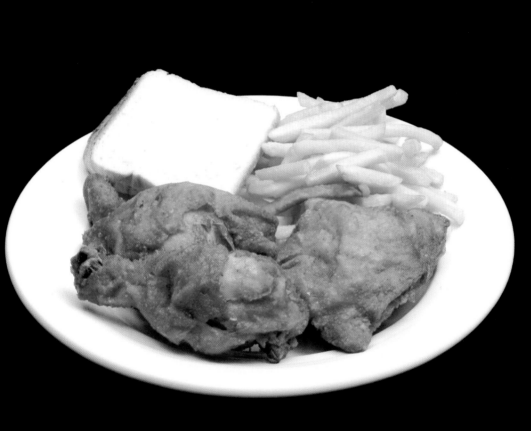

NO WHITE PERSON HAS EVER
BEEN EXECUTED IN GEORGIA FOR
THE MURDER OF A BLACK VICTIM.

Amnesty International

In 1987, a landmark case came
before the Supreme Court
of the United States.

In *Mcleskey v. Kemp*, attorneys
argued that, in violation of the Fourteenth
Amendment which promised equal
justice, he was being discriminated
against because of his race and because
of the race of his victim.

He asked that his death sentence
be overturned.

Statistics compiled for this case
by David Baldus showed that in
2000 murder cases in Georgia in
the 1970s, people charged with killing
whites were 4.3 times more likely to get a
death sentence than those who killed
blacks.

The Supreme Court stated that the Baldus study may indicate "a discrepancy that appears to correlate with race," but "apparent disparities in sentencing are an inevitable part of our criminal justice system."

The Courts ruled against McCleskey, 5–4.

In 1991, he was executed by the citizens of Georgia.

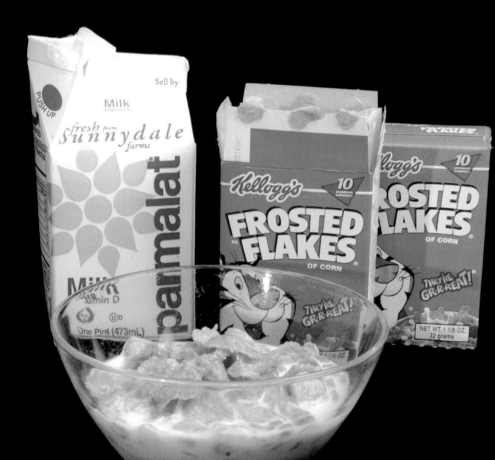

```
┌─────────────────────┐
│                     │
│                     │
│   PHOTO NOT         │
│   AVAILABLE         │
│                     │
│                     │
└─────────────────────┘
```

NAME: JEFFREY ALLEN BARNEY

EXECUTED: APRIL 16, 1986

NO BACKGROUND INFORMATION GIVEN

LAST STATEMENT: "...I AM SORRY FOR WHAT I'VE DONE. I DESERVE THIS. JESUS FORGIVE ME."

NAME: DAVID WAYNE STOKER

EXECUTED: JUNE 16, 1997

EDUCATION: 8 YEARS

OCCUPATION: HEAVY EQUIPMENT OPERATOR/CARPENTER

LAST STATEMENT: "...I AM TRULY SORRY FOR YOUR LOSS...BUT I DIDN'T KILL ANYONE."

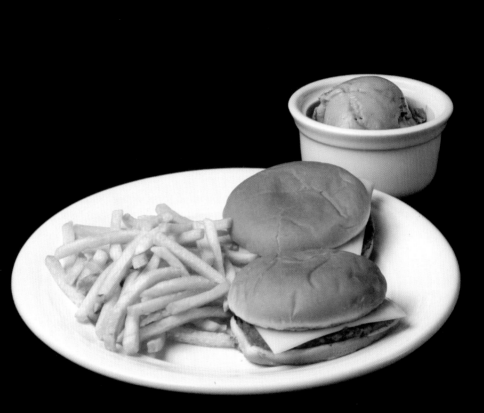

David Wayne Stoker's case exemplifies many of the things that can go wrong for a capital crime defendant:

- The prosecution's star witness was paid by a crime–stopper program and had drug charges against him dropped.

- The district attorney's investigator and the police gave false testimony.

- Less than two years after Stoker's trial, his lead attorney surrendered his law license and pleaded guilty to criminal charges.

- Stoker's other court–appointed attorney had been a lawyer less than a year.

The *Chicago Tribune*, June 11, 2000

There is no question that some of the condemned have committed heinous crimes and deserve some form of punishment, but 107 people once sentenced to death have been exonerated and freed. This number is climbing.

Overturning death row sentences for the innocent might be claimed as evidence that the system works. But many reversals have come not by virtue of the normal appeals process but through diligent discovery by journalism students, investigative journalists, DNA evidence and through work by experienced attorneys–all avenues that are rarely available to the typical death row inmate. DNA testing has contributed to freeing 12 of the wrongly convicted.

However, DNA evidence is not always available. Often it is not found at the scene of the crime and is therefore not available to exonerate defendants. Sometimes evidence was destroyed after trial.

NAME: STACY LAMONT LAWTON

EXECUTED: NOVEMBER 14, 2000

EDUCATION: 11 YEARS

OCCUPATION: CARPENTER

LAST STATEMENT: "...I DON'T WANT Y'ALL TO LOOK AT ME LIKE I AM A KILLER OR SOMETHING 'CAUSE I AIN'T NO KILLER. I DIDN'T KILL YOUR FATHER, I KNOW HOW IT LOOK, BUT I DIDN'T DO IT..."

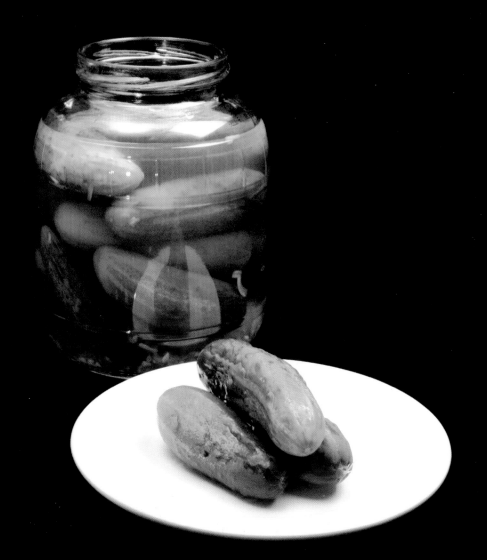

Another factor which increases the likelihood that innocents will be executed is the narrow time period allowed for appeals. Compounding this "deadline" is the withdrawal of federal funds for death penalty resource centers. Twenty of these offices were largely responsible for freeing many of the wrongly convicted.

Now, the lucky few whose appeals have not run out (Virginia's appeal period is 21 days after sentencing) rely on very limited opportunities for their cases to be reconsidered.

"Innocence and the Death Penalty" 1993 report for
House Judiciary Committee on Civil and Constitutional Rights

"PERPAPS THE BLEAKEST FACT OF ALL IS THAT THE DEATH PENALTY IS IMPOSED NOT ONLY IN A FREAKISH AND DISCRIMINATORY MANNER, BUT ALSO IN SOME CASES UPON DEFENDANTS WHO ARE ACTUALLY INNOCENT."

—JUSTICE WILLIAM J. BRENNAN, JR., 1994

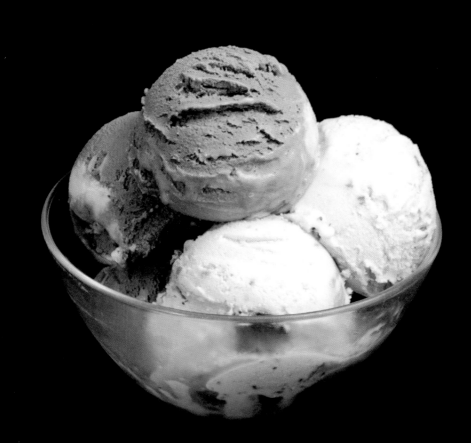

NAME: JOHNNY FRANK GARRETT

EXECUTED: FEBRUARY 11, 1992

EDUCATION: 7 YEARS

OCCUPATION: LABORER

LAST STATEMENT: "I'D LIKE TO THANK MY FAMILY FOR LOVING ME AND TAKING CARE OF ME. AND THE REST OF THE WORLD CAN KISS MY ASS."

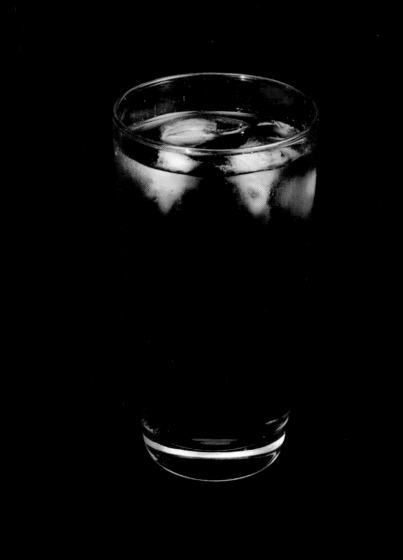

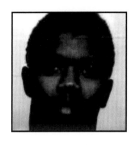

NAME: PATRICK F. ROGERS

EXECUTED: JUNE 2, 1997

EDUCATION: 10 YEARS

OCCUPATION: WAITER

LAST STATEMENT: "...DON'T LET THESE PEOPLE BREAK YOU. KEEP TRUE TO NATURE. YOU DO NOT HAVE TO ACT LIKE THEM. RISE ABOVE IT... PRAISE ALLAH."

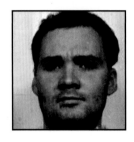

NAME: JAMES BEATHARD

EXECUTED: DECEMBER 9, 1999

EDUCATION: 15 YEARS

OCCUPATION: MOTORCYCLE MECHANIC

AFTER HIS TRIAL, THE PROSECUTION'S KEY
WITNESS RECANTED HIS TESTIMONY CASTING
ADDITIONAL DOUBT ON THE CASE AGAINST HIM.
THREE MEMBERS OF THE PAROLE BOARD HAD
RECOMMENDED CLEMENCY FOR BEATHARD.

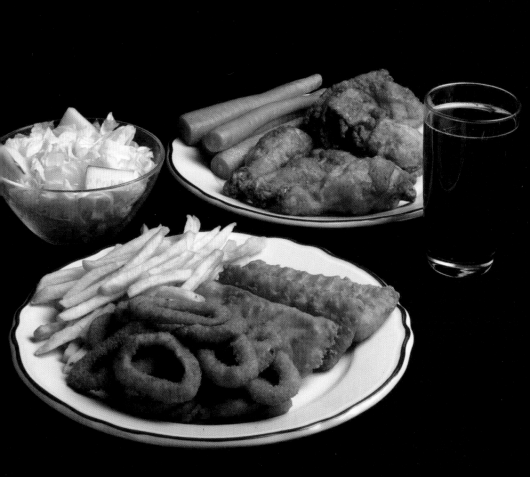

James Beathard's LAST STATEMENT:

"I want to start out by acknowledging the love that I've had in my family. No man in this world has had a better family than me. I had the best parents in the world. I had the best brothers and sisters in the world. I've had the most wonderful life any man could have ever had. I've never been more proud of anybody than I have of my daughter and my son. ...

Couple of matters I want to talk about since this is one of the few times people will listen to what I have to say. The United States has gotten (to a place) now where (there is) zero respect for human life. My death is just a symptom of a bigger illness. At some point the government has got to wake up and stop doing things to destroy other countries and killing innocent children. The ongoing embargo and sanctions against places like Iran and Iraq, Cuba and other places. They are not doing anything to change the world and they are harming innocent children...

Perhaps more important in a lot of ways is what we are doing to the environment is even more devastating because as long as we keep going the direction we're going the end result is it won't matter how we treat other people because everybody on the planet will be on their way out. ...

One of the few ways in the world the truth is ever going to get out, or people are ever going to know what's happening as long as we support a free press out there. I see the press struggling to stay existent as a free institution. ...

I would like to address the State of Texas and specially Joe Price, the District Attorney who put me here. I want to remind Mr. Price of the mistake he made at Gene Hawthorn's trial when he said that Gene Hawthorn was telling the truth at my trial. ...Gene Hawthorn lied at my trial. Everybody knew it. I'm dying tonight based on testimony, that all parties, me, the man who gave the testimony, the prosecutor he used knew it was a lie. I am hoping somebody will call him to the floor for recent comments he's made in the newspaper. It's bad enough that a prosecutor can take truth and spin on it and try to redoctor it. But when they actually make facts up and present to the public as trials evidence, ...that's completely unforgivable...

That's really all I have to say except that I love my family and nobody, nobody has got a better family than me..."

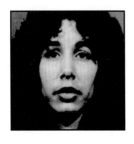

NAME: KARLA FAYE TUCKER

EXECUTED: FEBRUARY 3, 1998

EDUCATION: 7 YEARS

OCCUPATION: OFFICE WORKER

LAST STATEMENT: "YES SIR, I WOULD LIKE TO SAY TO ALL OF YOU — (THE FAMILY) THAT I AM SO SORRY. I HOPE GOD WILL GIVE YOU PEACE WITH THIS. ...I LOVE ALL OF YOU VERY MUCH. I AM GOING TO BE FACE TO FACE WITH JESUS NOW. WARDEN BAGGETT, THANK ALL OF YOU SO MUCH. YOU HAVE BEEN SO GOOD TO ME. I LOVE ALL OF YOU VERY MUCH. I WILL SEE YOU ALL WHEN YOU GET THERE. I WILL WAIT FOR YOU."

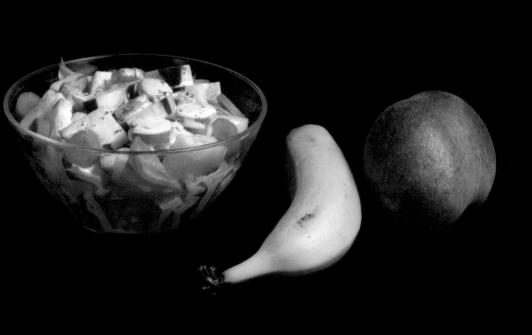

NAME: ROBERT ANTHONY MADDEN

EXECUTED: MAY 28, 1997

EDUCATION: 12 YEARS

OCCUPATION: COOK

LAST STATEMENT: "...I APOLOGIZE FOR YOUR LOSS AND YOUR PAIN, BUT I DIDN'T KILL THOSE PEOPLE. HOPEFULLY WE WILL ALL LEARN SOMETHING ABOUT OURSELVES AND EACH OTHER AND WE WILL LEARN TO STOP THE CYCLE OF HATE AND VENGEANCE AND COME TO VALUE WHAT IS REALLY GOING ON IN THIS WORLD...I FORGIVE EVERYONE FOR THIS PROCESS WHICH SEEMS TO BE WRONG. ..."

ASKED THAT FINAL MEAL
BE GIVEN TO A
HOMELESS PERSON.

(REQUEST DENIED)

NAME: JAMES EDWARD CLAYTON

EXECUTED: MAY 25, 2000

EDUCATION: 14 YEARS

OCCUPATION: CLERK

LAST STATEMENT: "I WOULD LIKE TO TAKE THIS TIME, TO USE THIS MOMENT (AS) AN EXAMPLE FOR CHRIST. I WOULD LIKE TO FOLLOW HIS EXAMPLE AND LEAVE WITH PEACE IN MY HEART AND FORGIVENESS. THERE IS NO ANGER IN MY HEART ABOUT THIS ENTIRE SITUATION. I JUST WANT TO TESTIFY TO ALL OF Y'ALL THAT I HAVE LOVED YOU. I APPRECIATE YOUR CONCERN AND GENUINE LOVE FOR ME. GOD BLESS YOU. I LOVE ALL OF YOU. JESUS IS LORD."

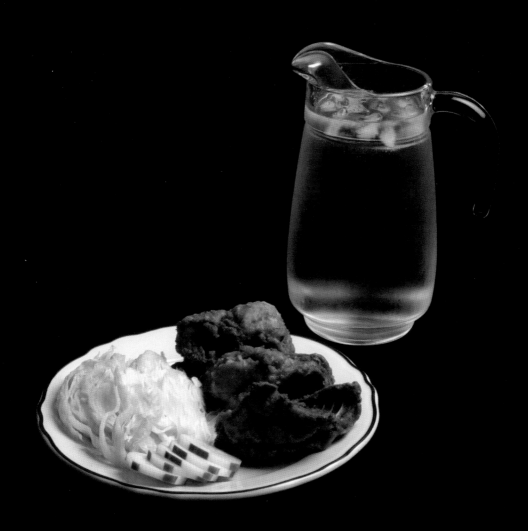

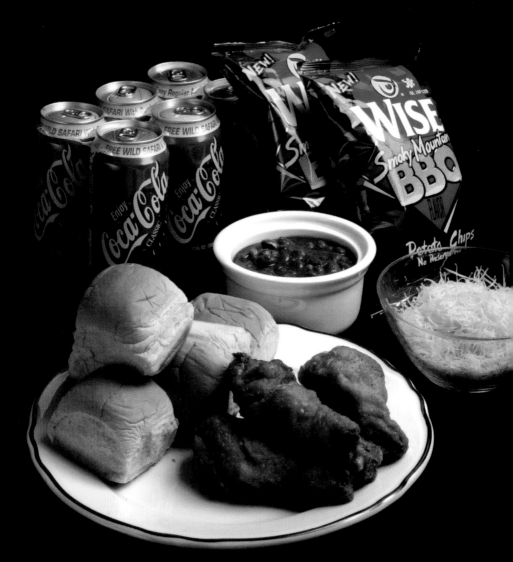

NAME: WILLIAM PRINCE DAVIS

EXECUTED: SEPTEMBER 14, 1999

EDUCATION: 7 YEARS

OCCUPATION: ROOFER

LAST STATEMENT: "...I WOULD LIKE TO SAY TO THE FAMILY HOW TRULY SORRY I AM IN MY SOUL AND IN MY HEART OF HEARTS FOR THE PAIN AND MISERY THAT I HAVE CAUSED FROM MY ACTIONS...I WOULD LIKE TO THANK ALL OF THE MEN ON DEATH ROW WHO HAVE SHOWED ME LOVE THROUGHOUT THE YEARS... I HOPE THAT BY DONATING MY BODY TO SCIENCE THAT SOME PARTS OF IT CAN BE USED TO HELP SOMEONE... THAT IS ALL I HAVE TO SAY, WARDEN. OH, I WOULD LIKE TO SAY IN CLOSING, WHAT ABOUT THOSE COWBOYS?"

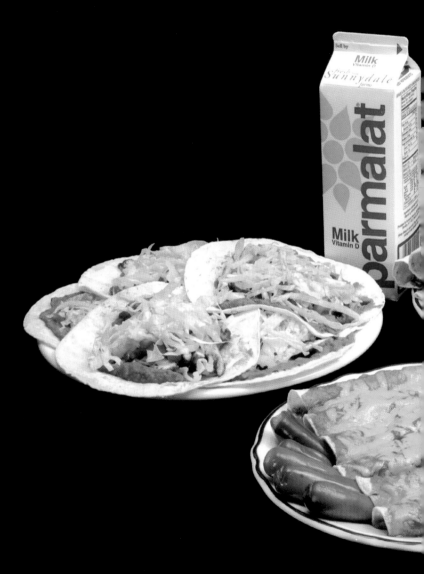

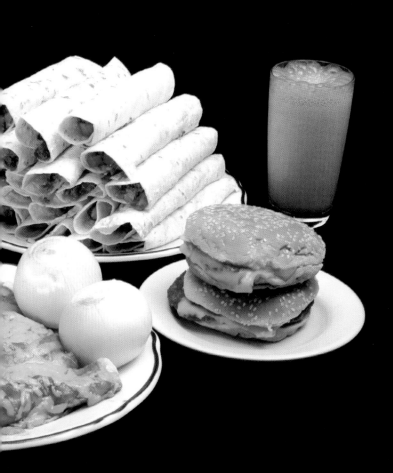

NAME: DAVID ALLEN CASTILLO

EXECUTED: AUGUST 23, 1998

EDUCATION: 9 YEARS

OCCUPATION: ELECTRICIAN

LAST STATEMENT: "...LITTLE PEOPLE ALWAYS SEEM TO GET SQUASHED. IT HAPPENS. EVEN SO, JUST GOT TO TAKE THE GOOD WITH THE BAD. THERE IS NO MAN THAT IS FREE FROM ALL EVIL, NOR ANY MAN THAT IS SO EVIL TO BE WORTH NOTHING...

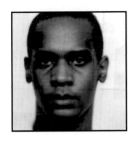

NAME: GERALD LEE MITCHELL

EXECUTED: OCTOBER 22, 2001

EDUCATION: 10 YEARS

OCCUPATION: CARPENTER

LAST STATEMENT: "...I AM SORRY FOR THE PAIN. I AM SORRY FOR THE LIFE I TOOK FROM YOU. I ASK GOD FOR FORGIVENESS AND I ASK YOU FOR THE SAME. I KNOW IT MAY BE HARD, BUT I'M SORRY FOR WHAT I DID. TO MY FAMILY I LOVE EACH AND EVERY ONE OF YOU. BE STRONG. KNOW MY LOVE IS ALWAYS WITH YOU, ALWAYS. I KNOW I AM GOING HOME TO BE WITH THE LORD. SHED TEARS OF HAPPINESS FOR ME. ..."

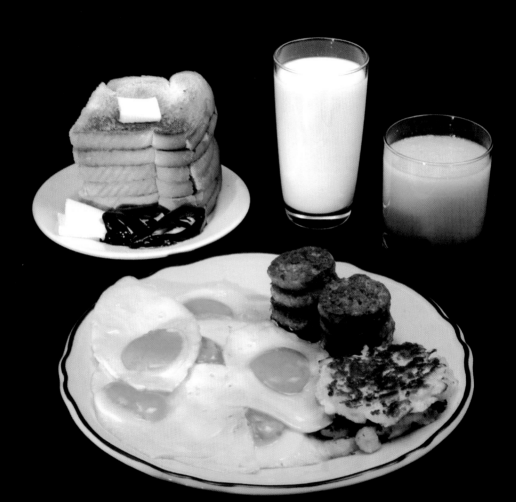

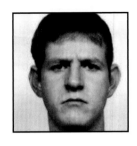

NAME: WILLIAM JOSEPH KITCHENS

EXECUTED: MAY 9, 2000

EDUCATION: 8 YEARS

OCCUPATION: PAINTER

LAST STATEMENT: "...I AM SORRY FOR WHAT I DID.
THERE IS NO WAY FOR EXPRESSING I AM SORRY.
I JUST HOPE THAT IN SOME KIND OF WAY THAT YA'LL
CAN MOVE ON AND FIND PEACE IN YOUR LIFE. THE
LORD HAS GIVEN ME PEACE AND THAT IS ALL THAT
I PRAY FOR IS THAT YA'LL CAN FIND THAT PEACE."

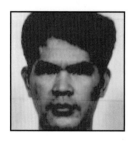

NAME: HAI HAI VUONG

EXECUTED: DECEMBER 7, 1995

EDUCATION: 7 YEARS

OCCUPATION: SHRIMPER

LAST STATEMENT: "I THANK GOD THAT HE DIED FOR MY SINS ON THE CROSS, AND I THANK HIM FOR SAVING MY SOUL, SO I WILL KNOW WHEN MY BODY LAYS BACK IN THE GRAVE, MY SOUL GOES TO BE WITH THE LORD. PRAISE GOD. I HOPE WHOEVER HEARS MY VOICE TONIGHT WILL TURN TO THE LORD. I GIVE MY SPIRIT BACK TO HIM. PRAISE THE LORD. PRAISE JESUS. HALLELUJAH."

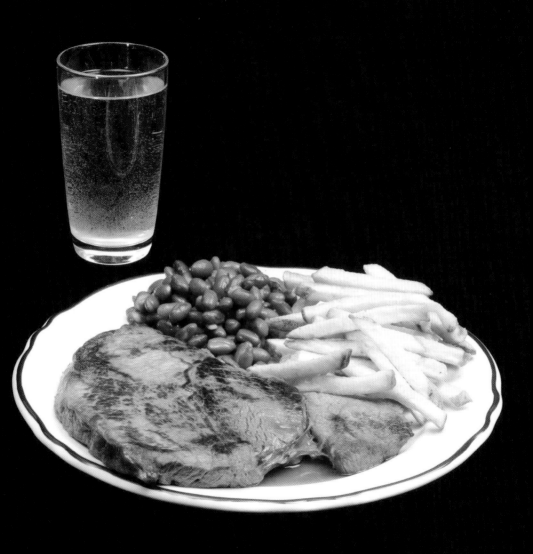

NAME: ROBERT STREETMAN

EXECUTED: JANUARY 7, 1988

NO LAST STATEMENT, NO BACKGROUND
INFORMATION AVAILABLE

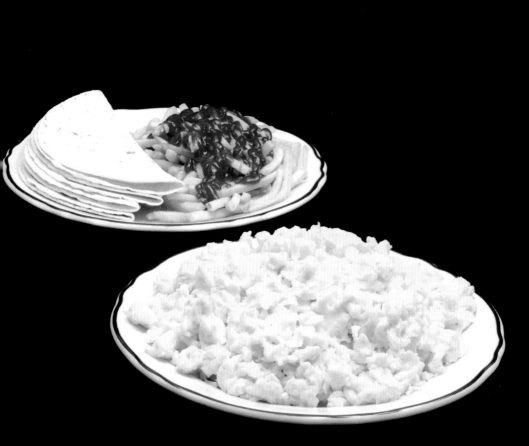

NAME: THOMAS ANDY BAREFOOT

EXECUTED: OCTOBER 30, 1984

EDUCATION: NOT LISTED

OCCUPATION: OIL FIELD ROUGHNECK

LAST STATEMENT: "I HOPE THAT ONE DAY WE CAN LOOK BACK ON THE EVIL THAT WE'RE DOING RIGHT NOW LIKE THE WITCHES WE BURNED AT THE STAKE. I WANT EVERYBODY TO KNOW THAT I HOLD NOTHING AGAINST THEM. I FORGIVE THEM ALL. I HOPE EVERYBODY I'VE DONE ANYTHING TO WILL FORGIVE ME. I'VE BEEN PRAYING ALL DAY FOR (THE VICTIM'S) WIFE TO DRIVE THE BITTERNESS FROM HER HEART BECAUSE THAT BITTERNESS THAT'S IN HER HEART WILL SEND HER TO HELL JUST AS SURELY AS ANY OTHER SIN. I'M SORRY FOR EVERYTHING I'VE EVER DONE TO ANYBODY. I HOPE THEY'LL FORGIVE ME..."

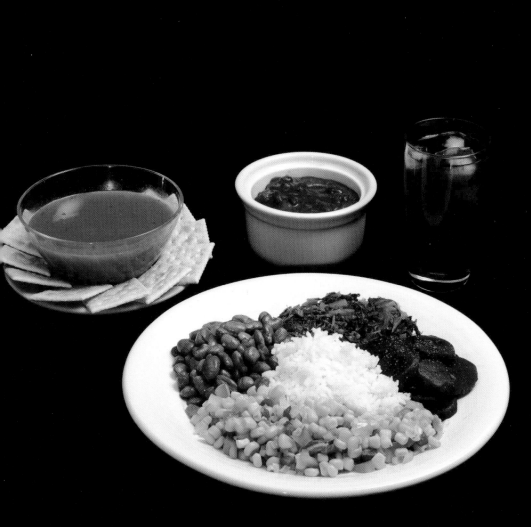

NAME: ODELL BARNES, JR.

EXECUTED: MARCH 1, 2000

EDUCATION: 11 YEARS

OCCUPATION: CONSTRUCTION WORKER

LAST STATEMENT: "I'D LIKE TO SEND GREAT LOVE TO
ALL MY FAMILY MEMBERS, MY SUPPORTERS, MY ATTORNEYS.
THEY HAVE ALL SUPPORTED ME THROUGH THIS. I THANK YOU
FOR PROVING MY INNOCENCE, ALTHOUGH IT HAS NOT BEEN
ACKNOWLEDGED BY THE COURTS. MAY YOU CONTINUE IN THE
STRUGGLE AND MAY YOU CHANGE ALL THAT'S BEEN DONE
HERE TODAY AND IN THE PAST. LIFE HAS NOT BEEN THAT
GOOD TO ME, BUT I BELIEVE THAT NOW, AFTER MEETING SO
MANY PEOPLE WHO SUPPORT ME IN THIS, THAT ALL THINGS
WILL COME TO AN END, AND MAY THIS BE FRUIT OF BETTER
JUDGEMENTS FOR THE FUTURE. THAT'S ALL I HAVE TO SAY."

LAST MEAL REQUEST:

JUSTICE, EQUALITY, WORLD PEACE

THE MEALS:

1. Charles Francis Rumbaugh: One flour tortilla and water

2. Clydell Coleman: Salmon croquettes, scrambled eggs, french fries, biscuits

3. Charles William Bass: Plain cheese sandwich

4. Billy Conn Gardner: Hamburger, french fries, tea and any dessert

5. James Russell: Apple

6. Anthony Ray Westley: Fried chicken, french fries, bread

7. Jeffrey Allen Barney: Two boxes of Frosted Flakes and 1 pint milk

8. David Wayne Stoker: Two double—meat cheeseburgers, french fries, ice cream

9. Stacy Lamont Lawton: One jar of dill pickles

10. Johnny Frank Garrett: Ice cream

11. Patrick Rogers: A coke

12. James Beathard: Fried catfish, fried chicken, french fries, onion rings, green salad, fresh carrots, a coke

13. Karla Faye Tucker: Banana, peach, and garden salad with ranch dressing

14. Robert Anthony Madden: Asked that last meal be given to a homeless person

15. James Edward Clayton: Three fried chicken breasts, fresh lettuce and cucumber salad with light vinegar dressing, a large pitcher of ice water

16. William Prince Davis: Chicken fried drumsticks, one bowl of chili, one bowl of cheese, five rolls, two bags of barbeque chips, six—pack of Coke

17. David Allen Castillo: 24 soft shell tacos, 6 enchiladas, 6 tostadas, 2 whole onions, 5 jalapenos, 2 cheeseburgers, 1 chocolate shake, 1 quart milk

18. Gerald Lee Mitchell: One bag of assorted Jolly Ranchers

19. William Joseph Kitchens: Half dozen sunny side up fried eggs, 8 pieces of pan sausage, 6 slices toast with butter and grape jelly, crispy hash browns, milk, orange juice

20. Hai Hai Vuong: Steak, french fries, beans, and water

21. Robert Streetman: Two—dozen scrambled eggs, flour tortillas, french fries and catsup

22. Thomas Andy Barefoot: Chef soup with crackers, chili with beans, steamed rice, seasoned pinto beans, corn o'brien, seasoned mustard greens, hot spiced beets, and iced tea

23. Odell Barnes Jr.: Justice, Equality, World Peace

REFERENCES:

Amnesty International
www.amnesty.org

Death Penalty Information Center
www.deathpenaltyinfo.org

www.prodeathpenalty.com

Texas Department of Criminal Justice
www.tdcj.state.tx.us

Amnesty International. 1989. "When the State Kills...
The death penalty: a human rights issue" New York

Amsterdam, Anthony. 1991. "The Death Penalty
Discriminates Against Blacks." *The Death Penalty,
Opposing Viewpoints*. San Diego. Greenhaven Press

Bonner, Raymond and Ford Fessenden. 2000. "Absence of
Executions: A special report." *The New York Times*, September 22

Cushing, Robert Renny and Susannah Sheffer. 2002. *Dignity Denied: The
Experience of Murder Victims' Family Members Who Oppose the Death Penalty*.
Cambridge, MA. Murder Victims' Families for Reconciliation.

Dieter, Richard C. 1997. "Innocence and the Death Penalty:
The Increasing Danger of Executing the Innocent"
Washington, DC. Death Penalty Information Center

Dudley, William, Editor. 1989. *Crime and Criminals. Opposing
Viewpoints Series*. San Diego. Greenhaven Press, Inc.

Gray, Mike. 2003. *The Death Game.* Monroe, Maine.
Common Courage Press

Loeb, Robert H. Jr. 1986. *Crime and Capital Punishment.*
Revised Edition. New York. Franklin Watts

McFeely, William S. 2000. *Proximity to Death.* New York.
W.W. Norton & Company

Mills, Steve, Maurice Possley, and Ken Armstrong. 2000. "Shadows
of Doubt Haunt Executions." *The Chicago Tribune.* December 17

Mills, Steve, Ken Armstrong, Douglas Holt. 2000. "Flawed Trials
Lead to Death Chamber." *The Chicago Tribune.* June 11.

Nelson, Polly. 1994. *Defending the Devil, My Story as Ted Bundy's
Last Lawyer.* New York. William Morrow and Company

Radelet, Michael L., Hugo Adam Bedau, Constance E. Putnam.
1992. *In Spite of Innocence.* Boston. Northeastern University Press

Rhodes, Richard. 1999. *Why They Kill* New York. Alfred A. Knopf

Scheck, Barry, Peter Neufeld, Jim Dwyer 2001. *Actual Innocence,
When Justice Goes Wrong and How to Make it Right.* New York.
Penguin Putnam

Sherrill, Steve. "Death Trip: The American Way of Execution." 2001.
The Nation. New York. January 8

Swindle, Howard. 1993. *Deliberate Indifference A Story of Murder and
Racial Injustice.* New York. Penguin Books

UPDATE:

On January 11, 2003 outgoing Republican Governor of Illinois George Ryan granted clemency to all 167 inmates on death row. This announcement came one day after the Governor pardoned four death row inmates who were wrongfully convicted.

Governor Ryan's actions came three years after appointing a Commission on Capital Punishment to study the issue.

Said Governor Ryan, "Our systemic case-by-case review has found more cases of innocent men wrongfully sentenced to death row. Because our three year study has found only more questions about the fairness of the sentencing; because of the spectacular failure to reform the system; because we have seen justice delayed for countless death row inmates with potentially meritorious claims; because the Illinois death penalty system is arbitrary and capricious and therefore immoral [as Justice Blackmun put it], 'I no longer shall tinker with the machinery of death'."